A CENTURY OF
RAILWAY
TRAVEL

Published in Great Britain in 2014 by Shire Publications Ltd, PO Box 883, Oxford, OX1 9PL, UK.

PO Box 3985, New York, NY 10185-3985, USA.

E-mail: shire@shirebooks.co.uk www.shirebooks.co.uk

A CIP catalogue record for this book is available from the British Library.

Shire Century no. 3. ISBN-13: 978 0 74781 373 6

Paul Atterbury has asserted his right under the Copyright, Designs and Patents Act, 1988, to be identified as the author of this book.

Designed by S.Larking and typeset in Swiss 721.

Printed in China through Worldprint Ltd.

14 15 16 17 18 10 9 8 7 6 5 4 3 2 1

A CENTURY OF
RAILWAY
TRAVEL

PAUL ATTERBURY

CONTENTS

INTRODUCTION

In 1913, Britain's railways were at their peak, and the envy of the world. The 20,000-mile network, created piecemeal by independent companies and private capital from the 1830s, now reached into the most remote corners of the country, linking cities, towns, villages and even hamlets. Very little remained to be added and indeed, by the 1930s, the network had actually started to decline, with the first significant closures of lines and stations taking place. However, in 1913 the railways were unchallenged as the primary passenger and freight carrier across the country; by making rail transport and travel universal and accessible they had put themselves at the heart of Britain's social and economic life.

In both World Wars the railways were vital to the nation's survival but the price each time was heavy, due to overuse and lack of maintenance. Recovery was by rationalisation. In the early 1920s all the independent companies were merged into four large regional groups, the SR, the GWR, the LMS and the LNER, a process encouraging modernisation and efficiency, as well as faster, more comfortable and better-promoted services. After the Second World War, the response was more drastic, with all the railways being nationalised and taken into government control. Modernisation was again the aim, but with the added challenge of the ever increasing competition from road transport that gradually drove the railways into deficit. Dr Beeching's Report of 1963, which recommended the closure of half the network and two thousand stations, was an attempt to stop the losses. Since then,

railways have always been subsidised by the government, a process that has continued even into the modern era of privatisation.

Railways have always attracted both enthusiasts and photographers and so the century from 1913 has been well documented. Many have photographed trains, and particularly locomotives, but others have also taken pictures of stations and station life. The railway station is, in many ways, the greatest legacy of the railway age, and photographs show its development from the Victorian era, its architectural diversity and its continuing impact on the travelling public. By 1913, the station had became a centre of social life, and the larger ones had hotels, restaurants, bars, shops, full postal and telegraph facilities, as well as public lavatories. A century on, the city station is sometimes more about shopping and entertainment than train travel. The photographs selected for this book offer an insight into all aspects of the railway century, from main lines to minor rural routes and from named trains and the age of steam to local diesel railcars. They document excursions, holidays and commuting, the impact of war, the changing role of women and the enduring passion of the trainspotter. They show city and country stations, the changing nature of railway publicity, classic locomotives and rolling stock and the colourful world of the modern railway. Above all, the focus is on the travelling public, the real heart of the railway network over the last century.

Festiniog Railway

This evocative photograph shows Tan-y-Bwlch station, the mid-point on the narrow gauge route from Porthmadog to Blaenau Ffestiniog. A train waits, headed by one of the railway's 1860s locomotives. By 1910 the Festiniog, whose history as a slate railway goes back to 1836, was concentrating on tourist traffic and marketing itself as a 'Toy Railway'. Photographs like this were taken for promotional purposes. When first opened, the Festiniog's slate traffic was operated by gravity, but steam was introduced in 1863, and passenger services soon followed. Always adventurous, the Festiniog pioneered articulated locomotives and bogie carriages, alerting the world to the potential of narrow gauge lines.

By the time this photograph was taken, slate traffic was in terminal decline. In addition, tourism was seasonal and unpredictable, thanks in part to the climate of North Wales, and in part to the increase in competing road traffic. By the 1920s the Festiniog, and other Welsh narrow gauge lines like it, were facing a difficult future. Closure came in 1946, but from 1955 the Festiniog was gradually reopened as a pioneering heritage railway, and in 1982 the restoration of the whole route to Blaenau Ffestiniog was completed. Today, the Festiniog, combined with the recently reopened Welsh Highland Railway, is Britain's most important narrow gauge line, and Tan-y-Bwlch station is usually busier than in this historical image.

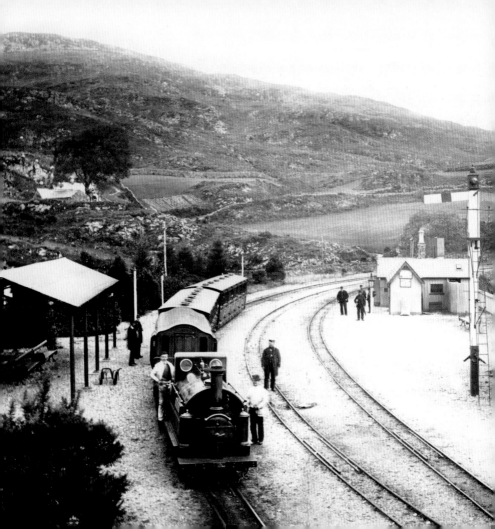

A Couple at the Window

This handsome couple posing in the window of a first-class compartment seem to capture the confident aura of Britain's Edwardian era. They are well-dressed, relaxed and confident as they wait for the train to depart and the photographer seems to have captured a universally familiar event. In fact, the image, taken for publicity purposes, shows Walter Passmore, a famous actor and singer associated with the D'Oyly Carte Opera Company, and his wife, the Scottish actress Agnes Fraser. The couple are representatives of a time when trains were for most people an essential part of daily life. The world of theatre and entertainment was especially indebted to railways. Actors and performers regularly travelled the length and breadth of Britain by train. The railways also transported sets and costumes, for which special goods wagons were available, and famously carried whole circuses around the country, including the animals. A theatre company could finish their last performance on a Saturday night and by the Monday morning everything could be set up in another theatre, sometimes hundreds of miles away. The railways also catered for theatregoers, running late trains from city and town stations to the suburbs and the country. Another reflection of the place of the train in Edwardian life was the large number of books, comic songs, plays and early films that featured railway settings or scenes.

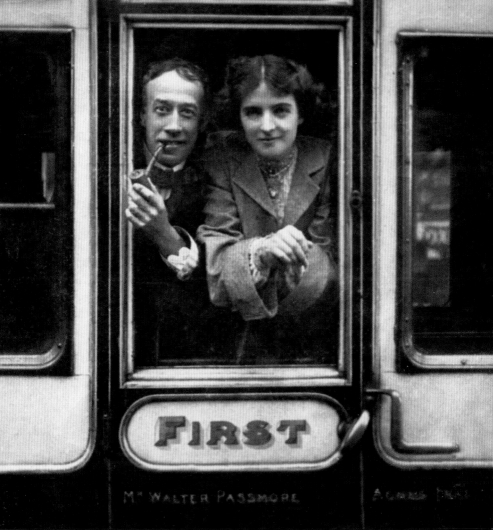

FIRST

Mr WALTER PASSMORE

Fashionable Folkestone, South Eastern & Chatham Railway poster

Colourful posters appeared at the end of the Victorian period, thanks to the development of high-quality commercial colour lithographic printing. Artists and designers were drawn to this new reproductive technology, while advertisers were quick to grasp the marketing potential of the poster.

Travel quickly became a popular subject for posters, with shipping and railways leading the way. Soon, billboards at stations and on the streets were filled with colourful and alluring images aimed at encouraging people to see new places and enjoy their leisure. The market was highly competitive but it was the South Eastern & Chatham Railway that had developed Folkestone as a harbour and resort, and they published this decorative poster to promote the town's attractions. Like many posters of the Edwardian era, the design, by an anonymous artist, is colourful, complex and a bit confusing, thanks to its many diverse images and messages.

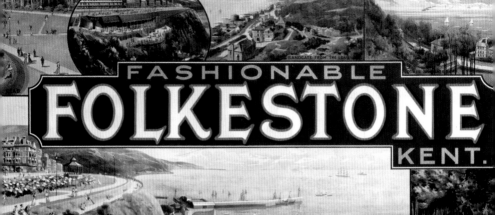

FASHIONABLE
FOLKESTONE
KENT.

SANDGATE FROM THE LEAS

PINE WALK

LIFT

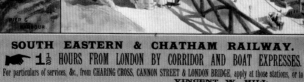

PIER & HARBOUR

BATHING MACHINES.

Platform Scene

On a country station platform in Edwardian Britain a smartly dressed lady waits for her train while a porter goes about his business. Both are aware of the photographer but are definitely not posing. Informal photographs of this kind are rare until the 1920s, mainly because cameras were cumbersome and often required long exposure times. At this time Britain's railway network was at its peak, connecting cities, towns and villages all over the country. Its place at the heart of Britain's economic and social life is apparent in the photograph. The lady, judging by her clothes and her confidence, is well-off and independent. She seems to be travelling alone, something inconceivable before the revolution the coming of the railways represented. The porter, comfortable in the uniform that defines his social standing, is, with his trolley laden with milk churns, a reminder of the vital role played by the railways in the distribution of food and agricultural products around the country. In 1914 the railways carried 93 million gallons of milk to London, 96 per cent of the city's consumption. Goods wagons lie in the sidings in the background – a reminder that the railways were the nation's primary carrier.

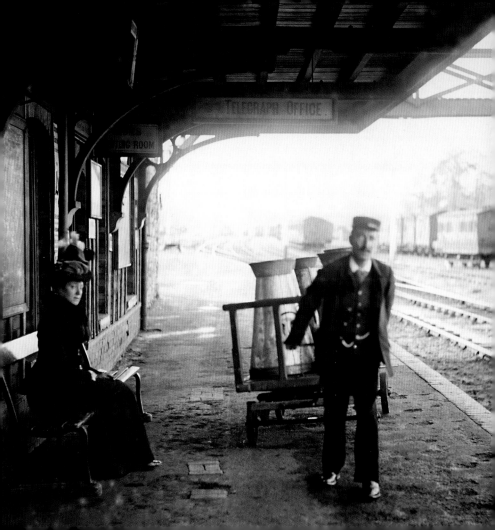

Railway Women

Despite a widespread belief to the contrary, women have always worked on the railways and around thirteen thousand women were employed in 1912, in railway works, mess rooms, refreshment rooms and hotels, and as clerks. Anything considered men's work was closed to women until the First World War. With the outbreak of war, thousands of male employees enlisted, and many jobs were taken by women at greatly reduced rates of pay. By 1917 women worked as porters and other station staff, ticket collectors and guards, horse-van and crane drivers, carriage and locomotive cleaners, shunters and signalwomen, even in engineering. The only thing women could not do was drive trains, and for this they had to wait until the Sex Discrimination Act of 1975. When the First World War ended over fifty thousand women were working on the railways. This photograph, taken at Liverpool Street station, London, shows women demonstrating the new uniforms they were to wear in the areas of employment now open to them in the Great Eastern Railway.

Women railway workers were always badly paid and often suffered from discrimination and intolerance. When the men returned, most women lost their jobs, though many stayed on as clerks and cleaners, and to perform other fairly menial functions. With the outbreak of the Second World War in 1939 women were again widely employed throughout the railway industry.

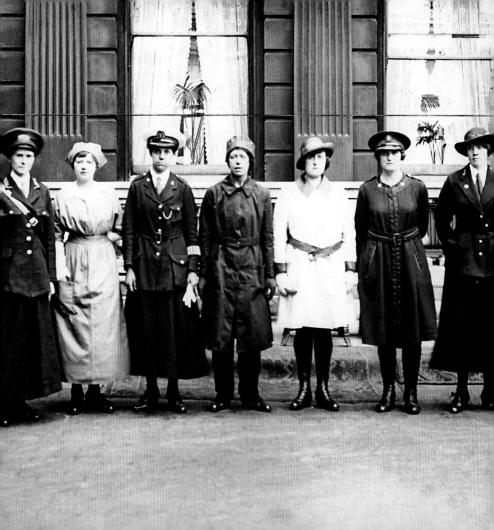

Bude Station

In the 1890s the London & South Western Railway, keen to challenge the Great Western's dominance of West Country goods and passenger traffic, supported the building of the North Cornwall line, a meandering route from Exeter across Devon and north Cornwall. The many tentacles of this network ultimately included Ilfracombe, Padstow and Bude, all reached at the end of long branch lines. From 1926 until 1964 the Atlantic Coast Express, a scheduled morning train from Waterloo, served all the nine destinations in this network, along with a complicated timetable of local services.

This photograph shows the main platform at Bude, on the north Cornish coast, a typical country station of the late Victorian era, during the late summer of 1923. Passengers are waiting to board a local train bound for Okehampton, Crediton and Exeter. The Southern Railway had recently taken over the network, following the Railway Act of 1921 that merged all railway companies into the Big Four, the SR, the GWR, the LMS and the LNER. This grouping had come into force on 1 January 1923. The smart-looking locomotive, freshly painted in Southern Railway colours, was actually quite old, having been built by the LSWR in 1895 as one of a small class of 0-4-4 express locomotives designed by William Adams. The line to Bude was closed in 1966, along with much of this network.

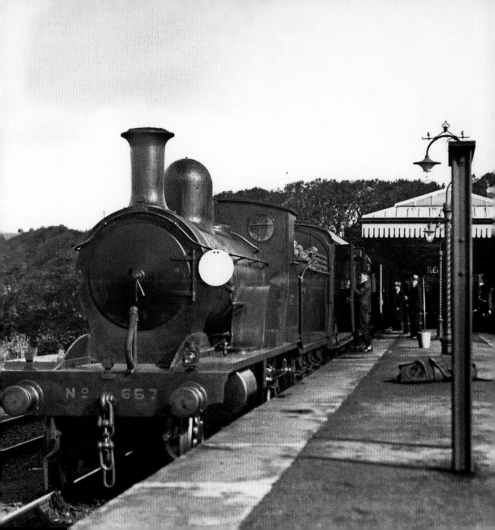

Blackpool North

When the first train reached Blackpool in 1846, the town had three thousand inhabitants. By 1900 this had risen to fifty thousand. Even more important were the three million summer visitors who came each year to enjoy one of Britain's premier seaside resorts. All this, including the seven-mile long promenade, the three piers, the famous tower, the hundreds of hotels and boarding houses and even the tramway network, was due to the railways. There were several routes to Blackpool, serving ultimately three stations. This is Blackpool North (formerly Blackpool Talbot Road) soon after the formation of the London Midland & Scottish Railway company. It was a vast station, extensively rebuilt in 1898 with fifteen platforms, designed to cater for seasonal holiday traffic, the majority of which came from England's industrial north. The photograph gives an idea of the station's grandeur, scale and decorative detail. Passengers wait, well-dressed in fashionable holiday clothes and hats. The bookstall, with all kinds of literature, souvenirs and advertisements, is the focus of attention. Such bookstalls first appeared in the 1840s and for many decades this market was dominated by W H Smith. From 1900 flower stalls, confectioners, tobacconists and chemists were also common features of larger stations. Now Blackpool North survives as the town's major station but it was totally rebuilt in 1974, and everything in this photograph has gone.

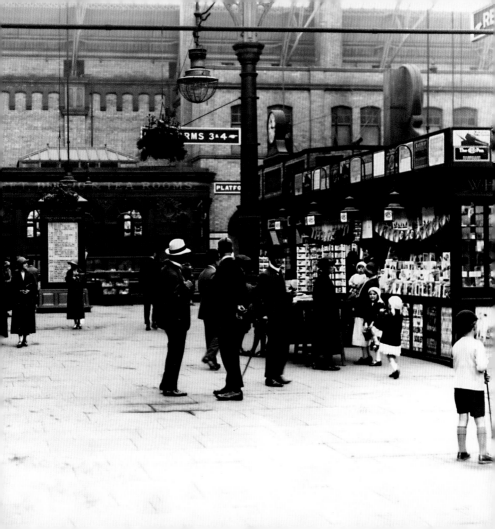

Clearing Snow

Railways have always been affected by weather, and severe gales and flooding continue to cause delays and cancellations to services and damage to track and buildings. However, snow is the worst of the natural hazards faced by railway companies. Snow falls caused problems on the Liverpool & Manchester Railway in 1830, and have continued to do ever since, particularly in the north of England and Scotland. Apart from regularly bringing traffic to a halt, and burying trains in the middle of nowhere, snow has also been the cause of a number of major accidents.

The traditional way of dealing with snow was to send out gangs of men with shovels but from the 1860s snow ploughs, either attached to the front of the locomotive or specially built as separate vehicles, were in regular use. The largest could deal with drifts up to 12 feet deep.

This 1920s photograph shows one of these large ploughs struggling to force its way through huge drifts, while railwaymen use ropes to clear a mass of overhanging snow. The location is unknown, but is probably in Scotland. It may be the Drumochter Summit on the main line to Inverness, one of the routes regularly blocked by drifts. In 1982, the line between Inverness and Wick, another route known for disruptions caused by extreme weather, was blocked by snow for a week.

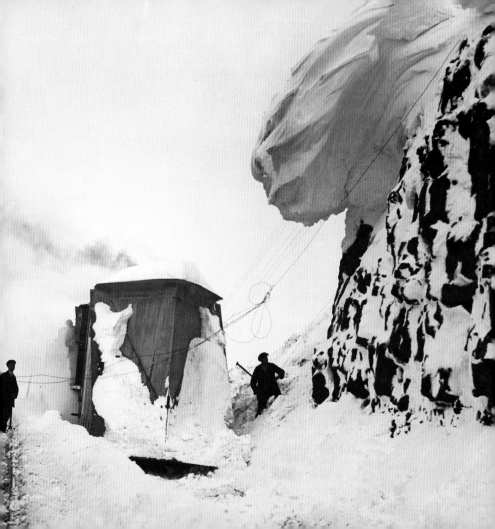

Crossing the Forth Bridge

When opened by the Prince of Wales in March 1890, the Forth Bridge was considered by many to be the eighth wonder of the world. What made it unique was its scale, its pioneering use of structural steel and its development of the cantilever principle of construction. From the start, there was a popular fascination with the bridge's statistics, including the weight of the steel, the numbers of rivets used and the cost. It took five years to build and there were fifty-seven deaths during construction. The bridge's complex patterns of steel tubes and lattice work have given it an enduring appeal to photographers, and it has appeared in countless postcards, books and films, most famously the various versions of *The Thirty Nine Steps*. Photographers have always enjoyed the sight of a steam train, high above the Firth of Forth, winding its way through the tangle of girders.

This photograph dates from the 1920s. It was obviously a carefully planned shot, with the train stationary or moving slowly towards the photographer, and may have been taken for publicity purposes, perhaps to promote the LNER's holiday business. Certainly, the bridge has appeared on many railway posters over the years and even today, long after the ending of steam, crossing the Forth Bridge is still a high point on any train journey going north from Edinburgh.

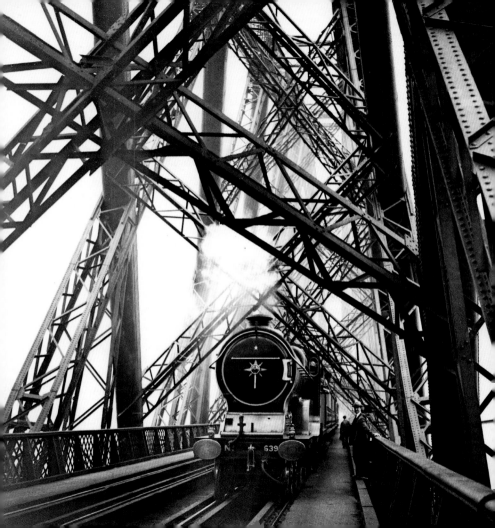

Holiday Crowds, Liverpool Street

London's Liverpool Street station was opened by the Great Eastern Railway in 1875 and then regularly redeveloped and enlarged. The result was a confusing terminus, with platforms linked by a network of elevated walkways, which, while offering exciting views, were little help to the traveller unfamiliar with the station's layout. It was, in any case, a station famous for overcrowding, particularly during the peak hours, thanks to the extensive network of commuter services operated by the GER.

This photograph from the 1920s shows a different kind of overcrowding, for the concourse is packed with holidaymakers struggling to find their trains for their journeys to east-coast resorts such as Clacton, Southend, Yarmouth, Lowestoft and Cromer. Some may be waiting for boat trains to take them to the continental terminal at Parkeston Quay, near Harwich, for railway-operated steamer services to Belgian, Dutch and German ports. By this time the LNER was in charge, and trying to make sense of the rather chaotic station it had inherited. There were various redevelopment plans, but nothing happened until the 1980s.

This dense throng of people, with their children, suitcases, hats and holiday cheerfulness is a record of a time when holiday travel was always by train.

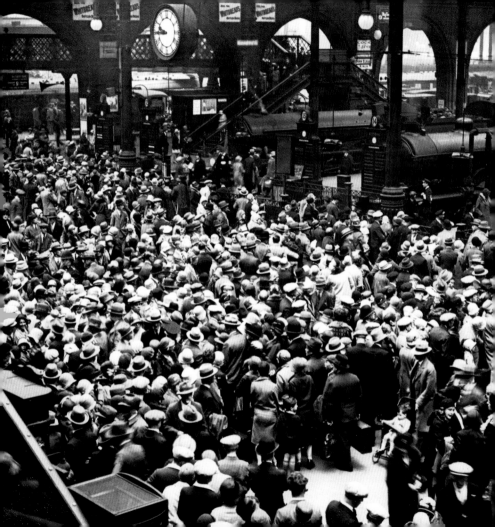

Platform No.1, Paddington Station

It is nearly 10.30 a.m. on a summer's morning in 1927, and the daily Cornish Riviera Express is about to depart from Paddington's Platform No.1. This fast service to Penzance via other West Country destinations, introduced by the Great Western Railway in 1904, has continued to run in one form or another up to the present day. As such, it is one of Britain's best-known named services.

The platform is a turmoil of activity as the last boxes, bags and cases are loaded and platform staff encourage passengers on to the train so the doors can be closed. In a couple of minutes the whistle will blow and the big green-painted and copper-trimmed locomotive, perhaps carrying the name of a famous castle, will slowly ease the heavy train out of the station. Meanwhile, the platform, also a busy through route between the taxi stand and the station concourse, is crowded. There are families with children, businessmen in groups, men and women travelling on their own and friends stopping to pass the time of day, all well-dressed. On the left, signs identify all the facilities then considered essential in any big terminus.

This photograph, taken by the GWR for publicity purposes, offers a rich insight into Britain in the 1920s, revealing that the train was still at the centre of everyday life.

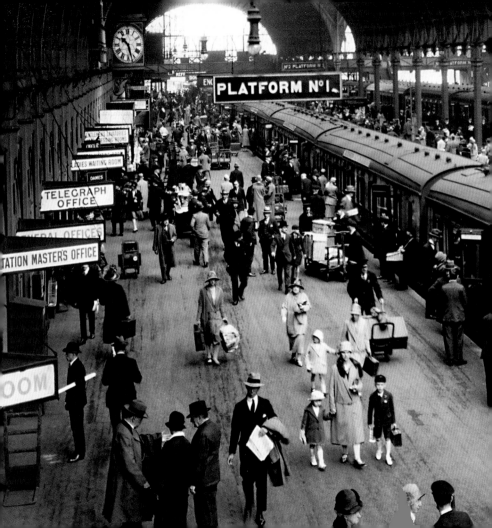

Lady Traveller

The train has come to its final stop and all the doors are open onto the platform. A cheerful lady traveller takes the opportunity to pose for a photograph, taken presumably by a friend or relation. The photograph is dated 14 August 1929. By then, informal photographs of this kind were much more common, thanks to easy-to-use portable cameras and roll film. At the end of the 1920s, women were able to enjoy without comment the sense of independence and pleasure captured by the photographer, and the railways had played their part in bringing about the social revolution represented by female emancipation. From the start, railway companies did their best to make lady travellers feel comfortable and secure. There were waiting rooms for ladies at many stations, sometimes with female attendants, and many trains had carriages with 'Ladies Only' compartments. Eventually, these were given up because they were so little used. The Victorian unease, shared by both men and women, at finding themselves alone in a railway compartment with a member of the opposite sex, had largely disappeared by the Edwardian era. By offering social equality and employment opportunities, and by encouraging leisure activities, the railways did much to advance the cause of the independent woman.

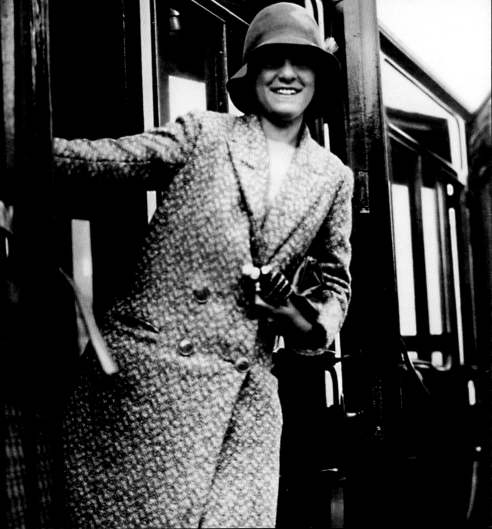

Inside the Carriage

Throughout much of the Victorian era, railway carriages were divided into separate compartments, without interconnecting doors or corridors. Indeed, for much of that time it was the guard's job to lock the compartment doors before the train left, and unlock them at each station. All this changed from the 1870s, with the development of the corridor train, with connecting passages between carriages, which in turn made possible the provision of dining and sleeping cars, and lavatories. However, compartment trains lived on, particularly for suburban and local services, at least until the 1980s.

This 1930s LNER publicity photograph shows a first-class smoking compartment in a corridor carriage and is typical of a range of new passenger stock being introduced during that period. The fittings are luxurious and modern, particularly the plush Art Deco upholstery, the cushions, footrests and curtains, and the smart, indirect lighting. Apart from the luggage racks, it looks more like a living room. There would also have been mirrors on the walls, and perhaps some framed views of resorts served by the LNER. The style and quality of this compartment reflect an era when train travel was considered to be fast, fashionable, comfortable and reliable.

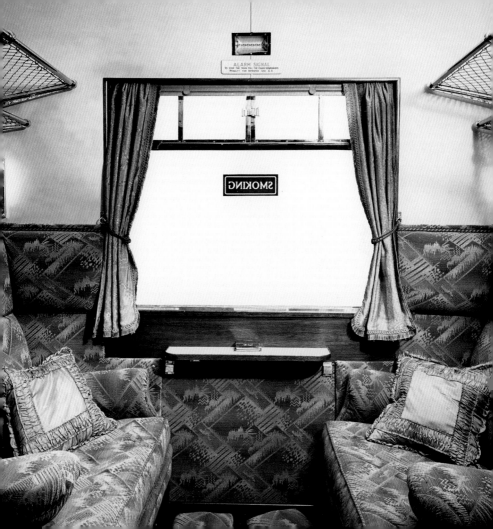

Promoting Holidays by Train

Competition between railway companies was well established in the Victorian era, with holiday traffic always an important battlefield. If anything, the intensity of competition increased after the formation of the Big Four in 1923, with the application of sophisticated marketing techniques to woo the travelling public. This was the great age of the decorative poster, with enticing images often drawn by leading artists. Also widely used were seductive leaflets, advertisements and holiday guides. West Country holiday business was a significant area of competition between the Southern Railway and the Great Western, with both offering services to parts of Dorset, Devon and Cornwall.

This delightful GWR publicity photograph comes from that time, and appears to show a handsome young couple preparing to leave the train at their holiday destination. Smartly dressed, they have enjoyed a comfortable journey in their reserved seats in a modern compartment carriage, and there has been plenty of room for their cases, golf clubs and tennis racquets. The view of the beach outside the window is enticing. However this is a carefully composed studio shot, probably taken in a real train compartment, but with the view, which looks a bit like south Devon, just a mounted photograph outside the window.

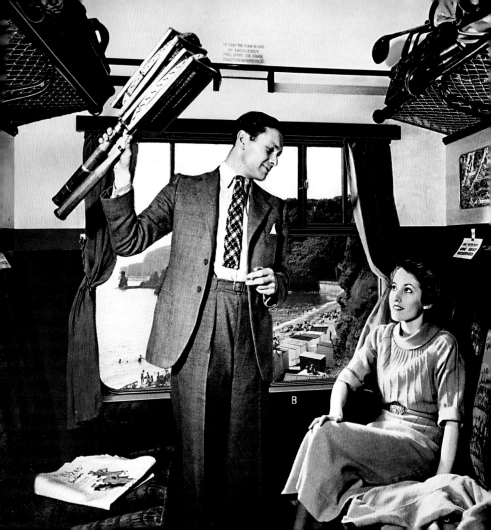

Aberdeen, the Silver City by the Sea, Joint LMS/LNER Poster

By the 1930s, travel posters had developed a familiar look, thanks to the use of colourful landscape, urban or resort scenes based on paintings or designs by well-known artists. These scenes, which filled most of the poster space, leaving only a narrow band at the bottom for text or captions, were deliberately alluring, tempting people to visit the area or region depicted. By this time the holiday habit was well established, and the railways competed fiercely for leisure and off-peak traffic. Through this decade the poster was the primary advertising medium, though most of the big companies also published a range of holiday guides.

This 1935 poster, issued jointly by the LMS and the LNER, features a decorative view of Aberdeen and its beach, based on a painting by Alexander Matheson McClellan (1872–1957). Delightfully detailed, it shows families on the sands, tramcars, a bandstand and bowling greens, all aimed at promoting Aberdeen as a seaside resort.

THE FINEST BEACH
AND MOST BEAUTI
FUL HOLIDAY RESOR
· IN BRITAIN ·

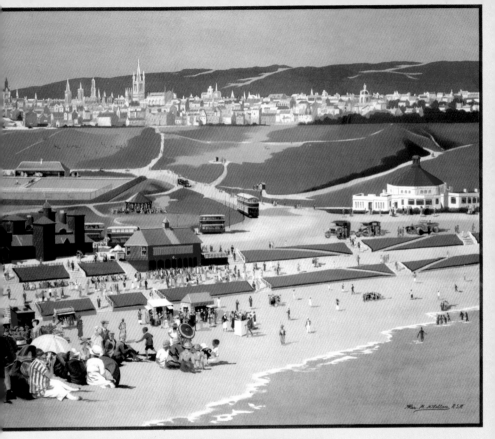

ABERDEEN
THE SILVER CITY BY THE SEA

DIRECT SERVICES AND
CHEAP HOLIDAY TICKETS
BY L M S AND L & N E
· RAILWAYS ·

An Excursion to the Biscuit Factory

Excursion trains date back to rail's earliest days, for companies were quick to recognise an easy way to make money. In 1844, a correspondent in the *Railway Chronicle* noted that excursions were 'our chief national amusement'. Excursion trains also launched a new profession, that of travel agent, the first being Thomas Cook, who took 570 people from Leicester to Loughborough in 1841 for a temperance meeting. As a result, the excursion, the special and the day trip became an important feature of Victorian railway life, both for entertainment and for education. After the grouping of 1923, the Big Four – the SR, the GWR, the LMS and the LNER – continued to run excursion trains, and they remained a revenue-earning part of the timetable until the end of British Rail.

Most excursions were to resorts, seaside towns, country houses, places of entertainment, sporting events and areas of scenic beauty. However, factory visits were always popular, particularly if the products were entertaining, useful or tasty. This 1930s group of mostly ladies seem to be keenly anticipating their visit to Huntley & Palmer's biscuit factory. Assembled on the platform at Reading station by a GWR photographer, they are happily smiling for the camera. One little girl has climbed onto the locomotive, GWR 'Hall' Class No. 4937, *Lanelay Hall*, and three ladies have even made their way into the cab.

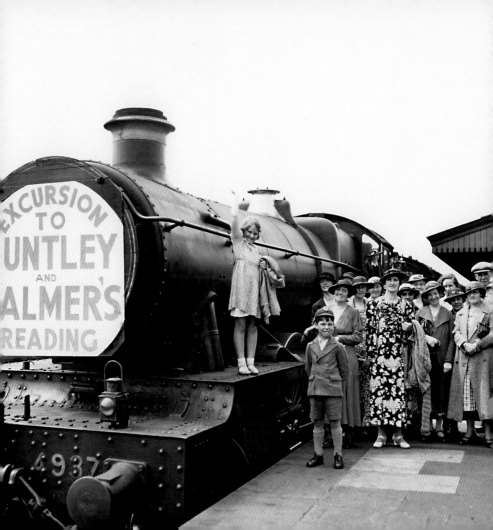

The Last Passenger

The Light Railway Act of 1896, which was designed to encourage the building of minor and rural railway lines by making construction and operation simpler and cheaper, prompted a short-lived railway building boom during the first years of the twentieth century. A number of standard gauge branches were built under the Act, along with some narrow gauge lines. One of the latter was the Ashover Light Railway, opened in 1924 to link Clay Cross and Ashover in Derbyshire. Minerals, notably limestone, fluorite, barytes and gritstone, were the primary inspiration, but passengers were also carried from March 1925. The rolling stock, including six Baldwin tank locomotives, was government surplus from the War Department. Initially successful and popular, the line soon suffered from road competition, and passenger services ended in 1936, though mineral traffic continued until 1950. As such, it was one of Britain's shortest-living railway companies.

Holmgate was one of the line's intermediate halts, and the basic nature of the railway and its buildings is apparent from the photograph, which was captioned at the time 'Last passenger from England's smallest station'. In fact, Holmgate station had closed in 1931 and so the carefully posed photograph was probably taken to mark the withdrawal of passenger services.

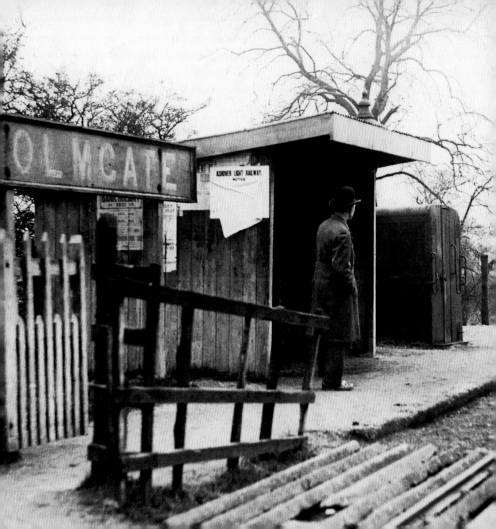

Young Enthusiasts and *Silver Fox*

Railways in general, and locomotives in particular, have always had a great appeal for young boys. Enthusiasts were common from the Victorian era, encouraged by a wide range of specialist books and magazines, and timing trains and collecting locomotive numbers were popular pastimes. This 1937 photograph shows a group of young enthusiasts enjoying an organised visit to a locomotive shed. As they are in uniform, it was probably a school outing. With one exception, they are all listening to the driver, who is telling them about his locomotive.

Silver Fox was one of a class of thirty-five streamlined A4 Pacific locomotives designed by Sir Nigel Gresley for the LNER and introduced from 1935. Initially, they were built to haul the Silver Jubilee, a new high-speed express linking London and Newcastle along the East Coast main line, and the first four locomotives, including this one, were silver-painted and had names including the word 'silver'. By 1937, the A4s were established as Britain's most famous streamlined locomotives, famous for their reliability and fast running. In July 1938 *Mallard*, one of the class, achieved the world speed record of 126 mph. Unlike their LMS rival, the 'Princess Coronation' Class, the A4s retained their streamlining all their active lives, until the last six were withdrawn in 1966.

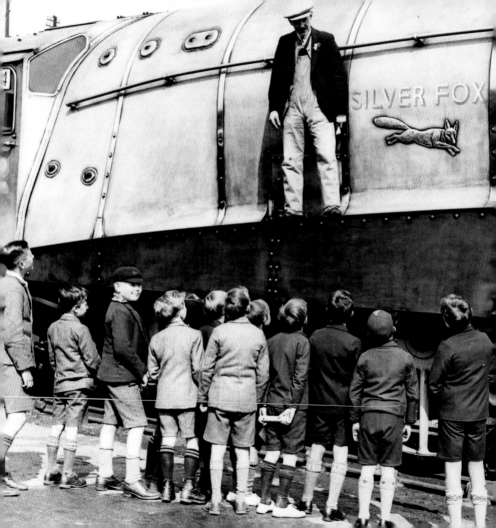

The Age of Steam

It is easy today to have a rather romantic view of steam locomotives, one that is actively encouraged by heritage railways and preservation societies. Things were actually rather different when the railways of Britain were completely steam-operated. While technically quite simple, a steam locomotive was always a difficult and demanding machine to drive and to maintain, and great skills were constantly required from the driver and the fireman to keep it running efficiently. Starting a heavy train out of the platform and up a gradient was always a challenge, often resulting in the production of clouds of smoke and steam.

In this photograph an LNER express has climbed up the slope from Liverpool Street station and is now approaching Bethnal Green. The signal box, and those working inside it, are about to be enshrouded in thick grey smoke and dust, which will also spread over the platforms and the people standing on them. This would happen many times on every working day. In retrospect, the age of steam seems to have been a golden one, but the reality was a world in which smoke, grime, dust and hard work were ever present.

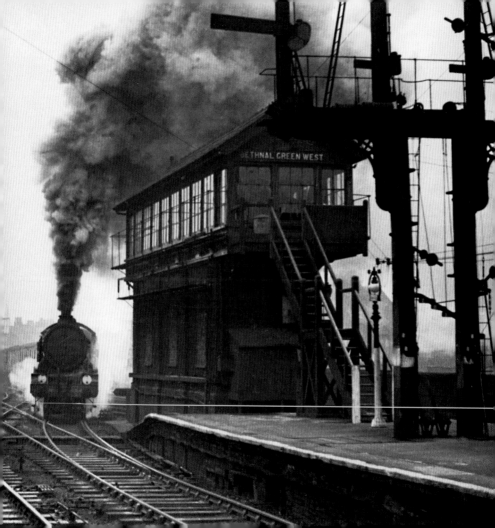

The *Coronation Scot* at Euston

During the 1930s, Britain produced two great classes of streamlined locomotives, the LNER's A4 Pacific designed by Sir Nigel Gresley and the 'Princess Coronation' Class designed for the LMS by Sir William Stanier. This photograph, taken at London Euston station in 1938, shows an LMS 'Princess Coronation' locomotive at the head of the Coronation Scot train, a special high-speed luxury service introduced in June 1937. The scheduled journey time between London and Glasgow along the West Coast main line was 6 hours 30 minutes. Fully streamlined and painted first in a dramatic blue and silver livery, later changed to crimson lake and gold, the locomotive was a magnificent sight, always attracting the attention of passengers and bystanders, male and female.

The 'Princess Coronation' Class locomotives were the most powerful in Britain and regularly travelled at over 100 mph. Research soon proved that streamlining for trains was more about the look than actually improving performance, and the casing made maintenance more difficult. Before too long, all the 'Princess Coronation' locomotives lost their streamlined casing, and performed just as well without it.

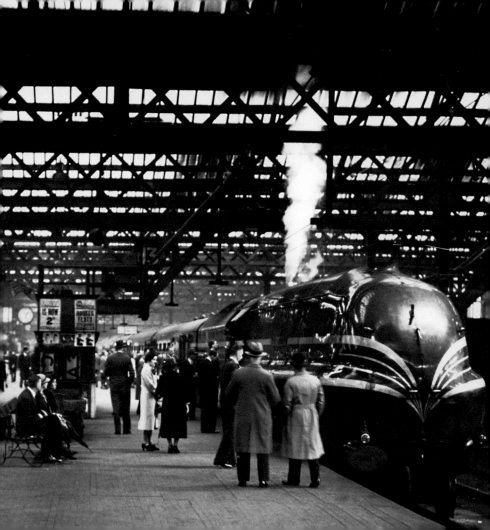

Waiting for the Evacuation Train

Plans to evacuate children, families and hospital patients from London and other major cities had been drawn up well before the outbreak of the Second World War, and the evacuation actually started on 1 September 1939. However, the main evacuation occurred in the summer of 1940, when the Blitz was raging, and invasion seemed imminent. During that period 805 special trains carried half a million people away from the cities and into the safety of the countryside. By 1941 most evacuees had returned to their families but the whole process began again in the summer of 1944 when the attacks by V1 flying bombs and V2 rockets started.

When evacuation started, city children were separated from their families and sent on their own to come to terms with the challenges of living in an unknown rural community. In September 1940, the government, aware of the negative propaganda generated by the sight of small children being sent off alone, introduced the mother and child scheme, which allowed 3,500 mothers and children to leave London together. This photograph shows such a group waiting for their train on a London platform.

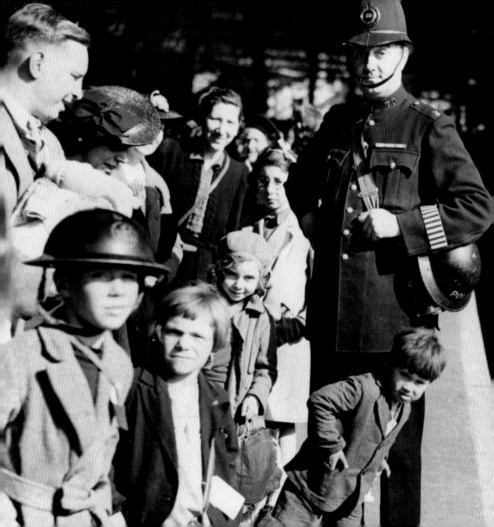

London St Pancras Station after a Bombing Raid

Throughout the Second World War Britain's railway network was crucial to the successful operation of the war, and even to the nation's survival. Trains took people to work, transported military equipment and personnel and carried vital supplies around the country. As a result, German bombers did their best throughout the war to bring it all to a standstill. Between 1940 and 1942 there were thousands of attacks on the network, with damage to stations and other buildings, track, signalling, bridges, workshops and junctions occurring almost on a nightly basis. Services were regularly interrupted but, thanks to adequate preparation, skilled engineering, the dedication of staff and improvisation, repairs were quickly carried out and the trains kept running.

Stations in and around London and other major cities were frequently attacked, with the aim of both disrupting services and damaging morale. However, no major station was ever permanently closed by enemy action. This scene of devastation greeted staff coming to work at London's St Pancras station after a raid in 1942. Yet, within a few days, things were back to normal.

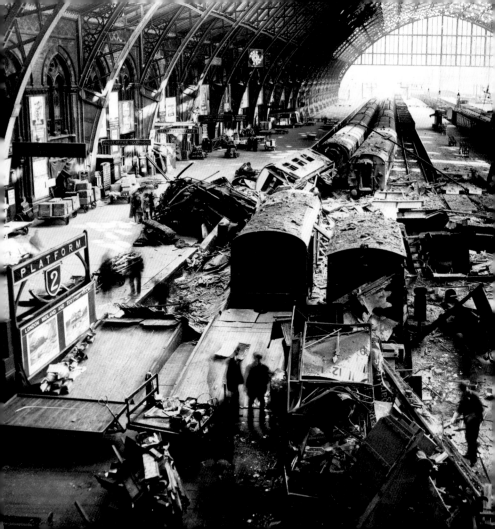

Sleeping Car Compartment

The first sleeper cars in Britain went into service in the 1870s and by the 1890s the standard layout, with single or twin-berth compartments connected by a side corridor, was established. From that date, sleeping car services proliferated on long-distance journeys all over the country. In 1946, Britain's railways were struggling to recover from the Second World War. Through that conflict the railways had played a crucial role, but the cost had been huge. Worn out locomotives and rolling stock, badly maintained track and infrastructure and damaged buildings faced managers trying to restore regular peacetime services. The Big Four were still in control, though nationalisation was on its way. This photograph, issued by the LMS in June 1946, was part of a campaign to assure the travelling public that the railways were back to normal. It shows a first-class sleeping compartment, with all its fittings and features on display. A pretty, and obviously well rested, lady traveller is receiving her early morning tea tray from the uniformed attendant. Second-, and at that time, third-class compartments were also available, containing two berths or four berths. Sleeping car services still operate on a few routes in Britain, and the layout of the compartments is much the same, though the tea is now served in a cardboard cup.

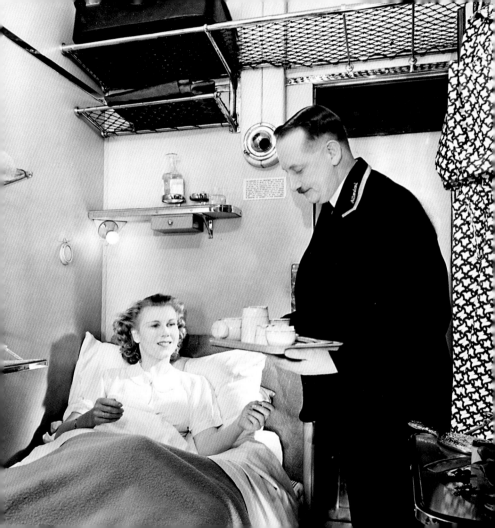

Station Advertising

Engravings published during the early years of the railways show stations with walls covered with advertisements, an indication that companies quickly appreciated the potential market represented by the travelling public. People waiting for trains gave manufacturers a new target for their products and this was quickly exploited. Soon, the walls of stations, other railway structures and fences were regularly covered with advertisements, some railway-related but the majority aimed at a general market. Once established, this type of advertising has continued to the present day.

This photograph, taken in August 1946, shows advertisements on a wall at Loughborough. At that time, the town still had two main-line stations, Midland and Central, and this is the former, a building dating from 1872. Central, dating from 1899, is now on a heritage line operated by the preserved Great Central Railway.

The advertisements are typically diverse, and cover both products and services that manufacturers and businesses hoped would attract the attention of the public. Included are medical products, chocolates, clothing, fountain pens, tools and insurance.

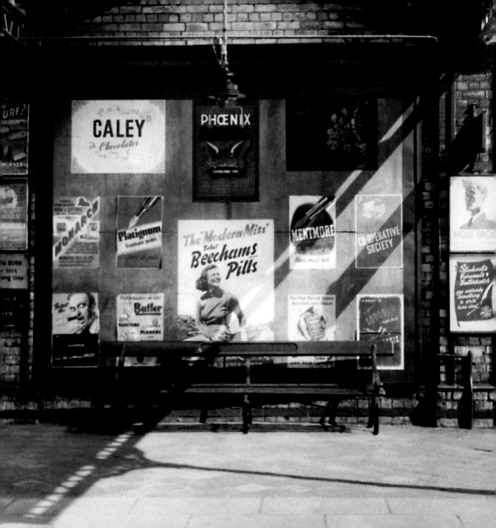

Tavern Car

The first restaurant car was introduced in 1879 and by 1900 restaurant and bar cars, with supporting kitchen cars, were in regular use all over the British network. From the Edwardian era, dining on trains became increasingly fashionable, and restaurant cars reflected contemporary interior design styles, influenced by competition between the various railway companies. Initially, French styles dominated but by the 1930s streamlined Art Deco modernism was all the rage. At the same time, dining became less formal, encouraging the development of buffet and bar cars whose styling tended to echo fashionable hotels.

During the late 1940s the newly nationalised British Railways worked hard to improve both its services and its image. New locomotives and rolling stock replaced those worn out by the heavy years of wartime service, and these included a new generation of restaurant, bar and sleeping cars. One of the innovations was the so-called 'tavern car' of 1949, introduced on Southern and Eastern Regions to try to bring the informality of the pub onto the train. Here, women in 'New Look' suits try out this strange timber-framed, leaded glass and pub décor look, a short-lived attempt at combining the traditional tavern with modern buffet car features.

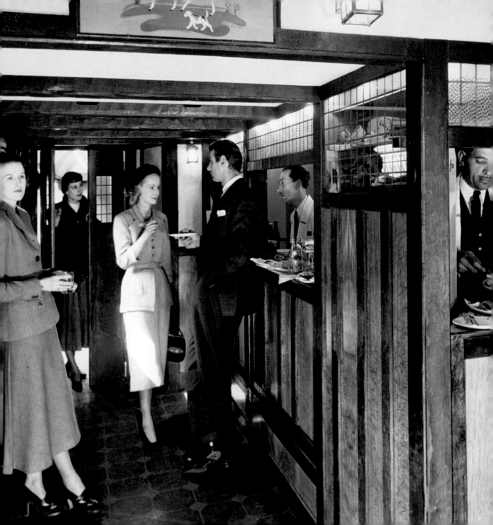

Classic Steam Scene, SR 'Merchant Navy' Class Locomotive, Shawford

One of Britain's most distinctive locomotives, in both appearance and engineering, was the air-smoothed Pacific designed for the Southern Railway by Oliver Bulleid. There were three classes, 'Merchant Navy', 'West Country' and 'Battle of Britain', introduced respectively in 1941, 1945 and 1946. In all 140 locomotives were produced, and they became the mainstay of British Railways' Southern Region through the 1950s and early 1960s despite recurring mechanical problems caused by the complex and sometimes revolutionary engineering involved. Nevertheless, they remained in service until the end of steam on the Southern Region in July 1967. Shortly before this, *Royal Mail Lines*, a member of the 'Merchant Navy' Class, achieved a recorded speed of over 105 mph with a service train, the last authenticated run at over 100 mph before the end of steam on the national network in 1968.

The photograph, taken in January 1954, shows 'Merchant Navy' locomotive 35019, *French Line* CGT, racing through a snowy landscape near Shawford station, south of Winchester.

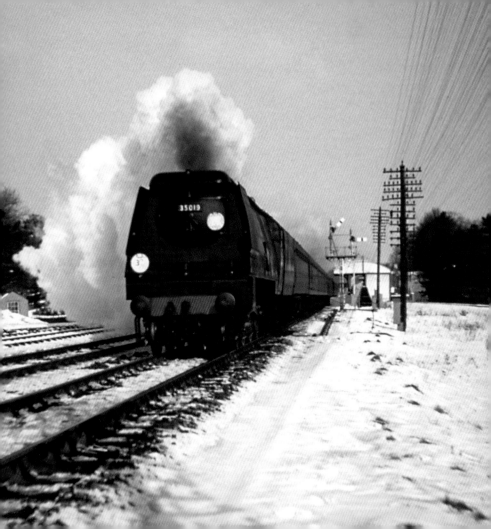

Waiting for the Train at Horncastle

circa 1954

This photograph shows a group of children waiting for a train to take them on an outing. They are in summer clothes, and some have towels and cameras. They are sitting cheerfully in a line along the platform edge, and the photographer, and one small boy, have climbed down onto the track. The adults, calmly watching, are well to the back, standing by the station buildings, though one mother in the distance seems to be carrying her child away. There are no station staff to be seen. At the time, such scenes were not uncommon, part of a tradition of photographing excursion groups surrounding a train or standing on the tracks that goes back at least to the 1880s.

Today, this is an inconceivable scene, thanks to modern health and safety regulations. Now, the group would be tightly controlled and kept to the back of the platform, under the care of adults wearing high-visibility vests. There would probably be station staff in attendance and no child would be allowed near the front of the platform until the train had arrived. No one would even consider sitting on the platform edge, and walking on the tracks would probably result in a large fine. Life was very different in the 1950s, and such ordinary situations like this were often much more straightforward.

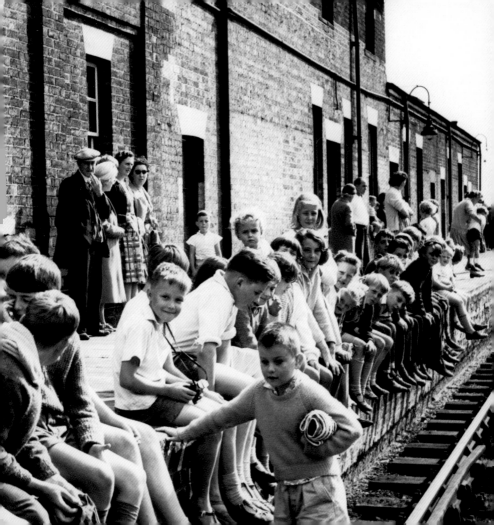

Weymouth, the Harbour Tramway

The Weymouth Harbour Tramway was opened by the Great Western Railway in 1865 to connect the town station with a harbour already busy with Channel Islands traffic. Initially the line, which winds its way through the town, was for freight, but passenger services started in 1889 to a new harbour station. Soon scheduled boat trains used the tramway, to transport passengers to and from steamers serving the Channel Islands and France. As traffic grew, so sidings were added and the harbour station expanded. Throughout much of the twentieth century the tramway remained busy with both passengers and freight, with Weymouth being the major port for the Channel Islands for both supplies and produce. At certain times the quays were stacked with crates of tomatoes, potatoes or spring flowers, awaiting onward transportation in railway wagons. This photograph from the 1950s shows a former GWR tank engine hauling wagons loaded with supplies for the Channel Islands towards the quay, surrounded by a rich selection of period vehicles.

Freight traffic ceased in 1972 but passenger trains continued to make their way through the town until 1987, preceded by two railwaymen with red flags walking in front of the locomotive. The Weymouth Harbour Tramway has never officially been closed and so all the track and infrastructure are still in place, though no train has used it since May 1999.

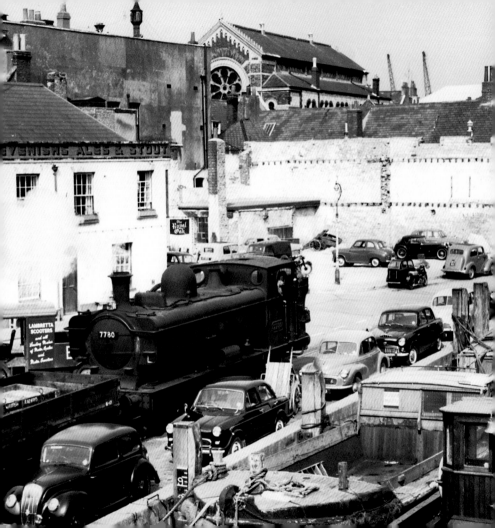

Classic Steam Scene, GWR 'King Class' Locomotive, Twerton

During the 1950s steam was still dominant throughout the British Railways network, with the last generation of steam locomotives being put through their paces every day. It was a good time to be a railway photographer, with no shortage of classic scenes that combined great locomotives with magnificent landscape settings.

This is Twerton, on the outskirts of Bath, on a summer's evening in 1956, as GWR 'King' Class locomotive 6003, *King George IV*, effortlessly hauls a Bristol-bound express out of the tunnel while the driver, with time to relax, watches the photographer. When introduced in 1927, the 'Kings', designed for the GWR by C. B. Collett, were Britain's most powerful railway locomotive. Well-regarded, and highly successful, the 'Kings' remained in service with British Railways until 1962. The Great Western main line from London to Bristol was I. K. Brunel's greatest achievement. Designed on a grand scale and built for fast running, the route was also marked throughout by great structures that reflected Brunel's genius as both engineer and architect. The Gothic portal of Twerton tunnel is a fine example of this legacy.

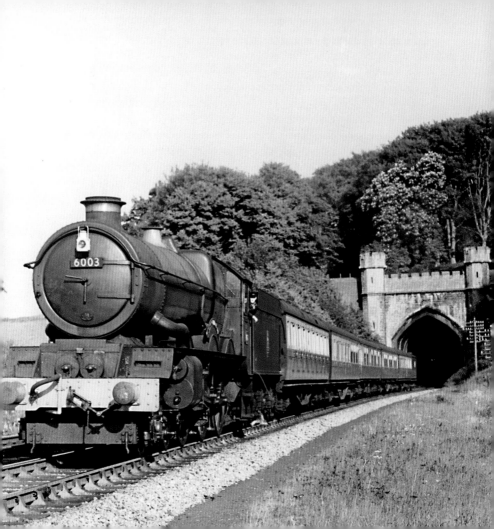

British Railways Carriage Interior

At its formation, British Railways inherited an extraordinarily diverse collection of rolling stock, some of which dated back to the Victorian era. Standardisation was an important principle in the new BR philosophy, and that was applied universally, to locomotives, rolling stock, station signage and uniforms. New carriages, built to satisfy both modern safety requirements and passenger comfort, were soon in service, and this pattern continued through the 1950s and 1960s. Most modern trains now had corridors, the carriages were connected, and there were plenty of lavatories, not always the case in the past. This carefully posed 1958 publicity photograph shows the new open-style central corridor carriages recently introduced on the electrified Kent Coast lines. This is a second-class carriage, though wall lights, curtains, comfortable and colourful upholstery, wood veneer finishes and luggage racks maintain a link with the smart Pullman interiors of the pre-war era. Carriages of this type were destined for a long life and some were still in service early in the twenty-first century when stock with individual passenger-controlled slam doors was finally withdrawn for safety reasons.

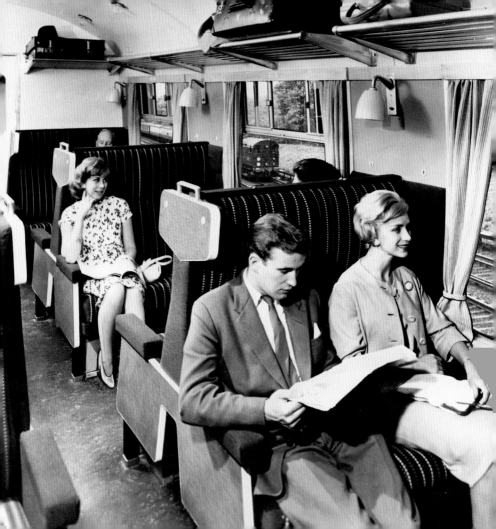

The End of the Line, Lauder

Although Dr Beeching's Report, published in 1963, was responsible for the closure of many thousands of miles of railways, along with two thousand stations, all deemed to be no longer economically viable, the closing of railway lines was nothing new. Between the 1920s and the 1950s three thousand miles were lost, and particularly affected were rural routes and branch lines. Such closures had a dramatic effect on isolated local communities, the impact of which was rarely considered by the railway companies involved. At the same time, imminent closure of a railway line often attracted the attention of enthusiasts, who travelled all over Britain to enjoy the line before it disappeared. This activity became more pronounced after the Beeching Report, as closures became more common and more widely reported. Indeed, an unexpected side effect of the Beeching Report was the rise of the preservation movement and the heritage railway.

This photograph shows the last train on the Lauder branch line in Scotland, on 15 November 1958, an astonishing scene that reveals both the great diversity of railway enthusiasts and the complete disregard for safety considerations by all and sundry, especially those balanced on the front of the locomotive.

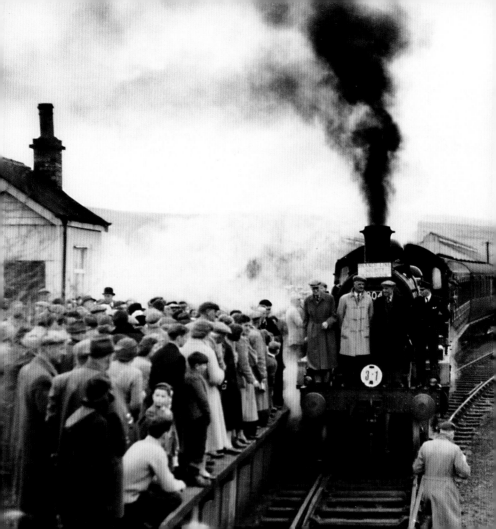

Observation Car, Fort William

The first observation cars, offering passengers panoramic views and designed to be attached at the rear of a train, were introduced about 1912. The first Pullman observation car came into service on the Glasgow to Oban route in 1914. Other famous examples were used on the LNER's Coronation Scot service between 1937 and 1939, and on the Devon Belle from Waterloo to the West Country between 1947 and 1954. The final appearance of the observation car on scheduled British Railways services was in Scotland from the late 1950s, though some are used today by heritage and preserved railways.

This 1958 photograph shows the former Coronation Scot observation car on the turntable at Fort William, being prepared for the afternoon train back to Glasgow. Ben Nevis forms part of the dramatic Highland setting. Images such as this are reminders of the complexity of railway operations in the steam era, when locomotives, and some vehicles, had often to be turned round before each journey. Turntables, now not used on the national network, were a common sight at all termini and large stations, and sometimes at the end of branch lines.

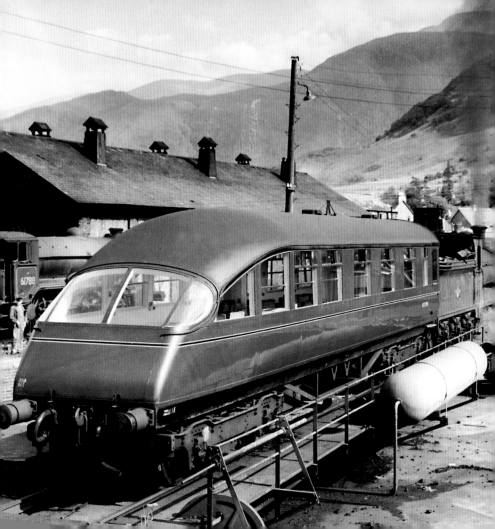

Diesel Multiple Unit, Birmingham

Railcars powered by petrol or diesel engines were in regular use by the 1930s, but it was not until the mid-1950s that British Railways began to introduce a new type of diesel railcar, designed to be used individually and as multiple units. Efficient, modern, comfortable for both passengers and crew and relatively cheap to operate, these were introduced for use on branch lines and rural routes, along with some main lines. Production was rapid and extensive, with over thirty different types being developed in the 1960s and 1970s.

In this 1959 photograph, the last passengers are preparing to board a three-coach DMU bound for Leicester, while a member of the station staff, or perhaps the guard, chats to the driver. The station is Birmingham New Street, a famously chaotic place, but, judging by the photograph, probably more pleasant to use than the subterranean monster that replaced all this in the 1960s. Period features include the destination fingerboard. Early DMUs like this pioneered the type of vehicle later used universally throughout the modern network. Now extinct except on preserved railways, they had one great advantage over their modern replacements: passengers could sit behind the driver and watch the journey unroll.

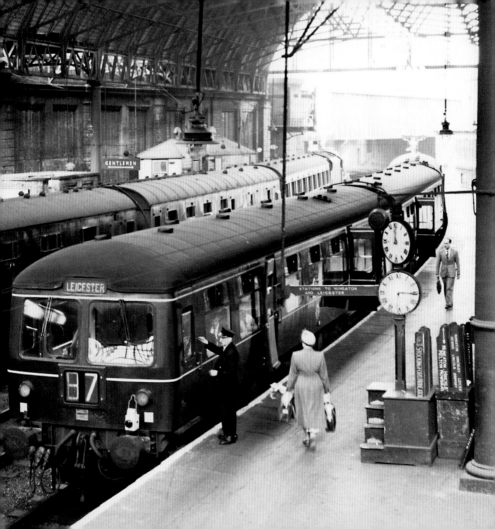

Classic Steam and Diesel Scene, A4 and 'Deltic' at London King's Cross

A detailed plan for the modernisation of British Railways, published in 1955, included track and infrastructure improvements, new rolling stock and the long-term replacement of steam by diesel and electric locomotives. Diesel locomotives had been used experimentally before the Second World War, and a number of designs were tested in the 1950s. However, they were technically complex, expensive to build, and often unreliable in use and so British Railways were compelled to keep using steam locomotives until 1968.

This photograph, symbolic of the handover from steam to diesel, was taken at London King's Cross early in 1961. In the background is 60028 *Walter K. Whigham*, a former LNER A4 streamlined Pacific, one of the greatest locomotives of the 1930s and at that point still doing sterling service for British Railways on the East Coast main line between London and Scotland. In the foreground, and dominating the scene, is D9003, an early example of the 'Deltic', or Class 55 diesel locomotive, introduced in 1961, and thus brand new in the photograph. The 'Deltic' name came from the Napier engine used in the locomotives, originally developed for use in naval vessels. This locomotive was later named *Meld*, after the famous racehorse.

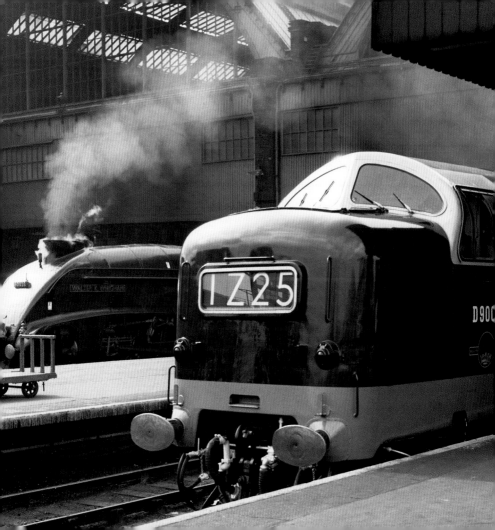

New Station at Barking

An important part of British Railways' modernisation plan was the rebuilding of stations considered no longer fit for purpose. This is Barking in east London, completed in 1961, to replace a building whose origins dated back to 1854. The design, by John Ward of BR's architects' department, was deliberately modern and open-plan, and used many contemporary building techniques, such as shuttered concrete, curtain-wall glazing, decorative mosaic finishes and uniform lettering. Opened by the Queen in 1961, Barking is now considered to be one of the best stations of that period, and has listed building status.

The spacious concourse style, with the clear separation between ticket office and retail outlets, was popular with British Railways at that time, along with the decision to keep the public areas open and accessible by not installing passenger seating. A number of stations were rebuilt along these lines in the early 1960s, the best-known being London Euston. The original Euston station, famously fronted by the great Doric portico designed by Philip Hardwick, was built from 1838. It was demolished in 1961, despite massive protests, to be replaced by the present bland and unfriendly airport-style structure. However, the nationwide outrage caused by this mindless example of corporate vandalism probably ensured the survival of St Pancras, the next major station on BR's destruction list.

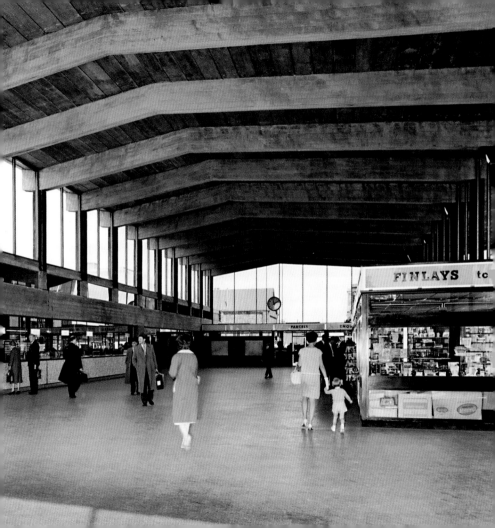

Ticket Office, Southend Victoria Station

In 1961 the ticket office at Southend's Victoria station was still equipped with racks holding great numbers of varied versions of the once familiar cardboard tickets. These tickets were for every possible journey, from station to station, as well as for special or discount fares, for separate classes of travel and additional complications such as children, dogs or bicycles. If the correct ticket did not exist, the clerk had to write it out by hand and keep a detailed record of the serial numbers. This type of ticket, which was preprinted with the journey details and a sequential serial number and then dated at the time of issue, had been developed by Thomas Edmundson in the 1830s and was to remain the standard ticket-issuing system until the 1980s. From the start, a railway ticket had three functions: to allow the purchaser to travel on the railway, to serve as a receipt for the passenger, and to ensure that the company received its dues. For this reason, ticketing was always complex and generated masses of paperwork, which had to be kept in order by the ticket clerks. The Railway Clearing House was set up in the 1840s to ensure that every railway company received its fair share of any particular journey, and it remained in operation until 1963. From the 1980s computers took control.

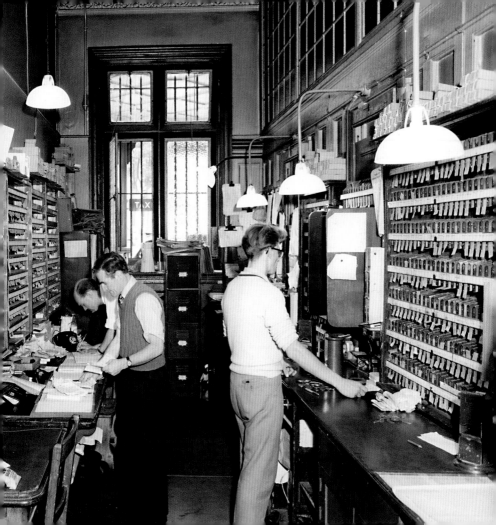

Going to Work, 09.15

The green-painted electric train from London's southern suburbs has come to a halt and the passengers are crowding onto the platform, ready to show their tickets at the barrier. The habit of commuting to work, well established by the late Victorian period, is a familiar weekday phenomenon for town and city stations all over the world. Many commuter services have dedicated trains, in some cases designed specially for this traffic. The passengers here seem self-contained and they are well dressed, the men with ties, and a few with bowler hats, the women with smart coats and headscarves or hats, representing a traditional approach to work clothing that was to start to disappear within a few years. There is little conversation. Most will probably have season tickets. Although first used in the 1830s, the season ticket did not really take off until the 1890s and by 1913 season ticket travel accounted for nearly one quarter of all railway journeys. By the early 1960s, when this photograph was taken, the season ticket, paid for in many cases by a company or bank loan, was an essential part of the process of travelling to work by train.

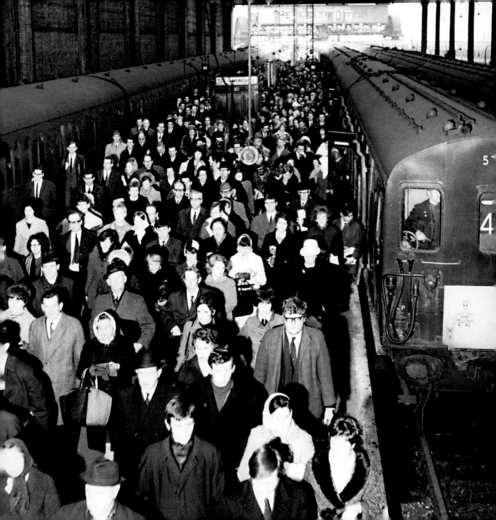

The Golden Arrow, London Victoria Station

Although the first named trains date back to the Victorian period, the habit of giving important scheduled services an official name did not really develop until the 1920s. Once started, it rapidly spread, and then was continued into the 1950s and 1960s, with well over a hundred named trains being recorded. A few are still in use today.

One of the most famous was the Golden Arrow, an all first-class Pullman service between London Victoria and Dover, launched by the Southern Railway in 1929. There had been earlier Pullman services on that route, but mostly unnamed. It was designed to complement the French Flèche d'Or, which had been introduced on the Calais to Paris route in 1926. These two first-class trains, with Pullmans in England and Wagons-Lits in France, and linked by a dedicated first-class ferry across the Channel, formed what became one of the world's great luxury rail journeys. The trains, decorated with golden arrows, headboards and flags, left London at 11 a.m. and Paris at 12 noon, and the total journey time was around six hours. Suspended during the Second World War, the Golden Arrow was relaunched in 1946, now with second-class seats as well, and then continued to run until September 1972.

This publicity photograph shows passengers preparing to board the train at London Victoria in 1963.

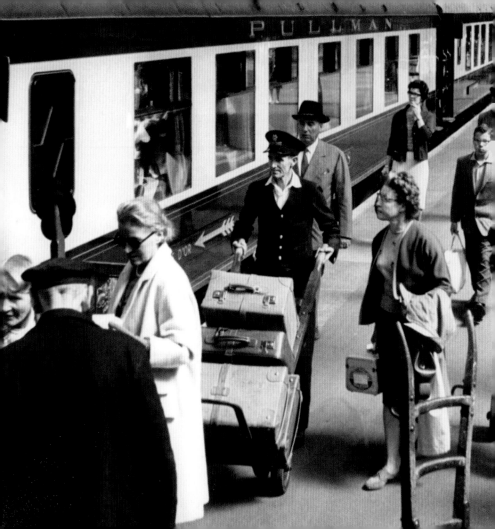

Langston Station, Hayling Island Branch

Britain's railway network expanded rapidly throughout the Victorian era, linking together cities, towns and villages all over the country. Particularly important for local communities were the many branch lines opened during this time, which encouraged both economic growth and social change by bringing mobility to areas that hitherto had been relatively inaccessible. There were hundreds of branch lines all over Britain, with the last ones being added to the map in the 1920s. Ironically, by this time some were already in decline, as they faced increasing competition from road transport. Early closures occurred in the 1930s, with many more following in the 1950s, but it was the Beeching Report of 1963 that really devastated the branch line network, with few examples surviving that destructive decade.

A typical example was the Hayling Railway, whose four-mile branch line from Havant to Hayling Island opened in 1867. Initially successful, and popular with holidaymakers over many decades, the line was in trouble by the 1950s and closed in 1963. This photograph shows a typical Hayling Island train approaching Langston station headed by one of the diminutive 'Terrier' tank engines, a survivor from the 1870s and a famous feature of the branch in its last years.

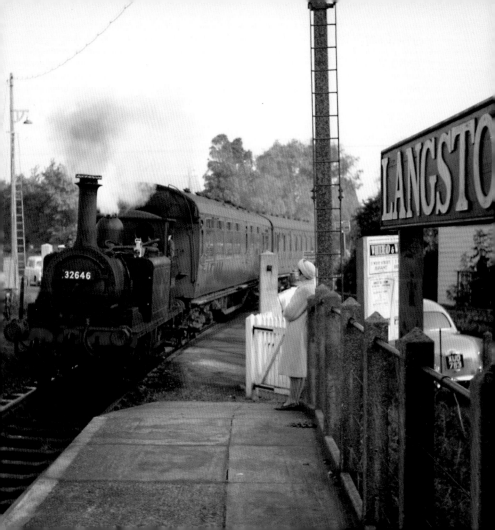

London Midland Electrification, British Railways Poster

Modernisation and standardisation were primary aims for the newly nationalised British Railways from the late 1940s, a broad vision that encompassed routes, stations, locomotives, rolling stock and the operation of the network. Image was also a key element, affecting liveries, uniforms, signage, services and publicity, which included printed material from timetables to posters.

A major project, launched in the 1955 Modernisation Plan, was the electrification of the West Coast main line between London and Scotland, achieved in stages between 1959 and 1974. The key section, linking London and Manchester, was completed in 1965. This poster, drawn by John Greene and issued by British Railways in 1963, was to remind the public that progress was being made, even though the project was far from complete. It shows a new Class 81 electric locomotive, in British Railways' new blue livery, preparing to leave Stafford for Manchester. Completed the previous year in a contemporary architectural style, Stafford was an important and pioneering example of how a big modern station should look. At this point, the aim was to remove as far as possible everything old or historical from the network.

LONDO

MANC

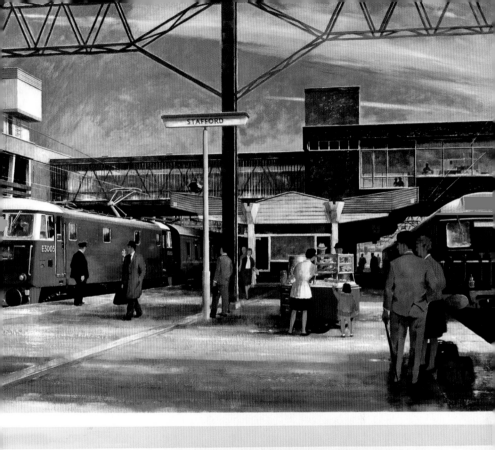

STAFFORD

N MIDLAND ELECTRIFICATION

STER – LIVERPOOL – CREWE – BIRMINGHAM – LONDON

TILL MAKING GOOD PROGRESS

Classic Diesel Scene, Approaching Bristol Temple Meads

This 1964 photograph shows a long train of British Railways maroon carriages on the curving approach to Bristol Temple Meads station, headed by a Brush Type 4, or Class 47 diesel locomotive, painted in the two-tone green livery then favoured for main-line diesels. The Class 47, developed initially at the Brush Falcon works in Loughborough, was a very successful locomotive design, with 512 built between 1962 and 1968, a few of which are still in use today.

The train is passing the goods yard, whose sidings are full of wagons, a reminder that at this time freight was still a valuable part of British Railways' business. Throughout the Victorian period and for the first half of the twentieth century, revenue from freight exceeded that from passenger traffic, and so was the backbone of the whole network. When this photograph was taken, railway freight traffic was rapidly diminishing, thanks to increasing competition from road transport, which was helped by the expanding motorway network. Soon, little was to remain for the railways except bulk cargoes and container traffic, and goods yards such as this would be empty and overgrown.

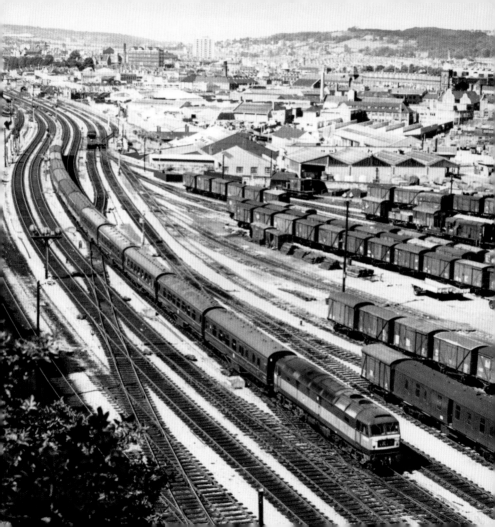

Filey Holiday Camp Station

Billy Butlin opened his first holiday camp in Skegness in 1936 and others quickly followed. Filey, in East Yorkshire, was scheduled for completion in 1939 but the Second World War intervened and the camp became RAF Hunmanby Moor until 1945, when it finally opened as a holiday camp. As nearly all campers travelled by train, easy rail access was essential for holiday camps, and many camps had their own railway station or rail link. The LNER built a short branch from the Yorkshire coast main line to serve Filey, and this opened in May 1947. The station had two long platforms designed to serve holiday specials, and a subway connection to the camp. By the nature of holiday camp life, the station was very busy at weekends and little used during the week.

This photograph shows campers at the station in June 1973, having arrived in two trains, a long holiday special and a local diesel multiple unit (DMU) service. The holiday camp's appeal to families is apparent. By this time, many campers were coming by car and so rail travel was less popular, a point underlined by the rather run-down look of the station platforms. Filey Holiday Camp station closed in July 1977, though the platforms still survive today.

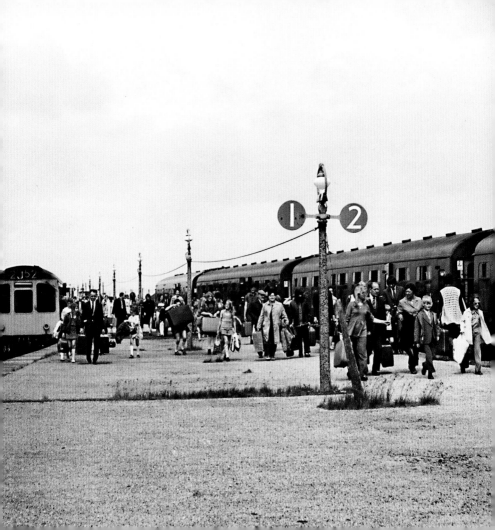

Trainspotting, Doncaster

Young boys have been drawn to trains for decades, and the appeal did not end with the passing of main-line steam, as the trainspotting gene seems to pass from generation to generation. Railway companies began to publish lists of their locomotives in the 1920s but this rather random process was formalised in the 1940s, with the appearance of the first of the Ian Allan ABC 'Spotters' Guides, with their comprehensive regional listing of locomotives and rolling stock. These, regularly updated, became the trainspotters' bible, and made the hobby universally accessible and popular.

It is not clear if these boys have their ABC Guides, but they are certainly making the most of the appearance of Class 55 Deltic diesel 55013, *The Black Watch*, at Doncaster station, as they stretch up from the usually forbidden area of the platform slope to take a rubbing from the locomotive's maker's plate. Flared trousers, long hair and a Qantas flight bag indicate the early 1970s. Today, in an age dominated by security cameras and health and safety concerns, this scene is inconceivable, though the lure of trains to boys of all ages is still undiminished.

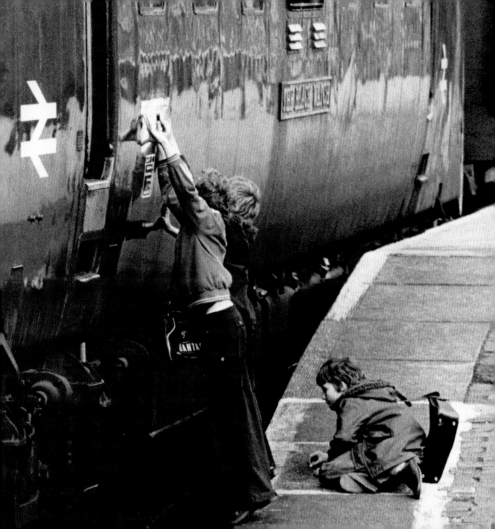

Going to Work, Kirkby Station

The last line closures prompted by the Beeching Report of 1963 occurred in the early 1970s but within a few years attitudes towards railways began to change. By the 1980s stations and lines were beginning to reopen, inspired by the development of new urban areas, and changing patterns of social and commercial travel, particularly in regard to commuting. A major element was the opening of urban Metro-type systems.

Kirkby station in Merseyside was originally opened in 1848, on a route between Liverpool and Bury. By the 1960s this was little used and so, in the late 1970s, this station was removed and converted into a single-platform interchange between Liverpool's urban network, Merseyrail, and a main-line service to Manchester via Wigan. Passengers walk between trains as there is no physical connection between the two lines. Here, commuters on their way home in 1978 leave the Merseyrail train at the end of the line at Kirkby, an indication of the passenger growth achieved by replanning routes and services to meet modern needs. Today, nearly two million passengers a year use Kirkby station.

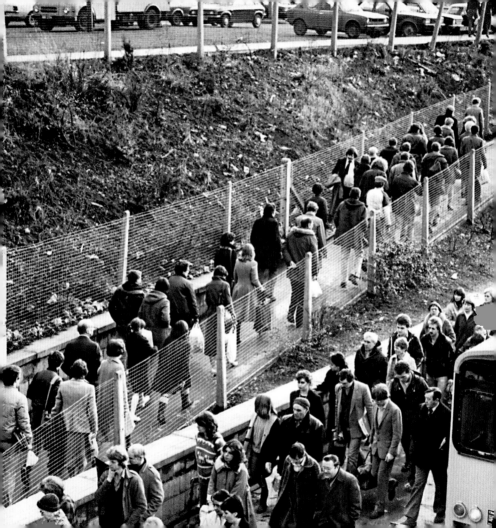

HST (High Speed Train), Selby

From the 1960s, British Rail was determined to produce a new generation of high-speed trains that could compete effectively with intercity journeys on the new motorway network. A prototype was tested from late 1972, and this determined the nature of the new train, which had seven new carriages sandwiched between two diesel power cars, and a service speed of 125 mph. The production trains, defined by a streamlined look and the sharp-nosed power cars created by designer Kenneth Grange, went into service from 1976, on various British main lines. Marketed as 'the fastest diesel train in the world', they were an immediate success and did much to improve British Rail's image, and its revenues. The HST, or Intercity 125, represented what British Rail called 'the age of the train'.

Many HST sets are still in use today, having gone through many operators and liveries, and been seen on routes all over Britain. After nearly forty years in service, their popularity and efficiency is unchanged, and examples are likely to remain in service for some time to come, particularly on unelectrified lines. This 1980 photograph shows an HST set in the British Rail livery of that time coming off the famous 1899 swing bridge over the River Ouse at Selby in Yorkshire.

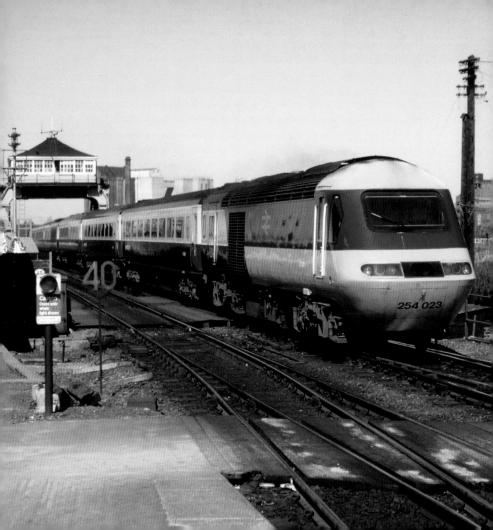

Georgemas Junction

In 1874, the line north from Inverness to Wick and Thurso, Britain's most northerly and remote railway journey, was completed. At Georgemas Junction, the train from Inverness separated into two sections, the front for Wick and the rear for Thurso. With locomotive-hauled trains, this involved a complicated manoeuvre, with a separate locomotive needed for the Thurso section. This process continued into the diesel era, as this 1987 photograph indicates. The main locomotive, a Class 37 diesel, would carry a snowplough in winter as this line was, and is, regularly affected by snow. At this time British Rail's locomotive livery featured the double-arrow symbol used very large. The second Class 37 diesel can just be seen behind the footbridge. Locomotive haulage ended on the route in the early 1990s, and the modern DMU units now in use simply split and go their separate ways.

Georgemas Junction remains as built in 1874, with the original Highland Railway iron footbridge still in use. In this timeless summer scene, the post van waits to receive the mailbags from the train, while the locomotive draws its train slowly into the platform.

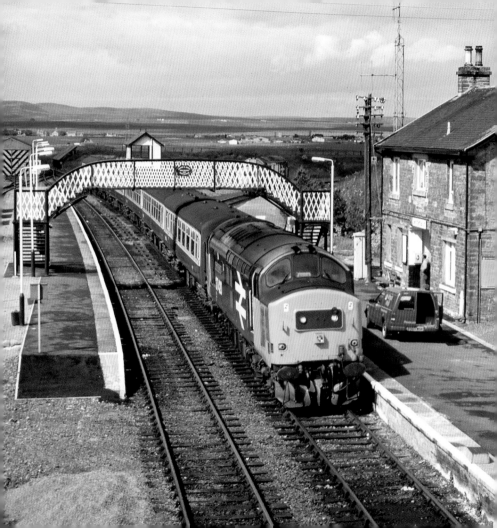

Class 90 Electric Locomotive with InterCity train

British Rail, keen to improve both its image and its services, introduced the InterCity brand from the mid 1960s, though initially it was spelt 'Inter-City'. It was used to define high-speed main-line services aimed primarily at the business sector. The launch of the brand in 1966 was linked to the new blue and grey corporate livery for rolling stock and locomotives. From the late 1970s, a new livery, with a grey upper section and a white lower section divided by a red band, was introduced, along with a relaunch of the InterCity brand. In 1987 this was modified again, with 'INTERCITY' in italic capitals, linked to a stylised swallow emblem.

This photograph, from about 1990, shows an InterCity train in this final version of the livery. The locomotive is a Class 90, the last of a sequence of high-speed electric locomotives developed by British Rail to operate both passenger and freight services on their electrified lines. Fifty Class 90 locomotives were built between 1987 and 1990, many of which are still in use, an indication of the high quality of British Rail's design and manufacturing and operating efficiency before its then imminent destruction by the privatisation process.

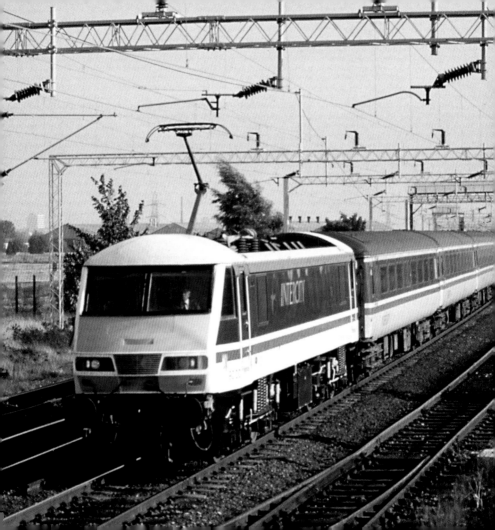

London Waterloo Station, Derby Day

Through much of the nineteenth century London's Waterloo station was famously chaotic, even to the extent of having two pairs of platforms numbered 1 and 2. In 1900 the London & South Western Railway finally decided to do something about it and launched a total rebuild, which was eventually opened by Queen Mary in 1922. The result was London's best station in terms of practical use and passenger convenience. The main feature was the spacious and well-lit concourse, with the famous clock hanging from the centre of the roof, the traditional meeting point for generations of friends and lovers. Today, Waterloo station is still a great public space, well able to handle the grand occasion, such as, in this case, Derby Day, June 2010. The real glamour of the Edwardian era may have gone, but it is still a time for smart dresses, hats and morning suits, scattered casually among the station's more regular passengers. Since this photograph was taken, a mezzanine floor, aimed mostly at retail outlets, has been built along Waterloo's grand curtain wall, to the left. This has been achieved without spoiling the station's sense of space, and it offers a great viewing platform for watching Waterloo at work.

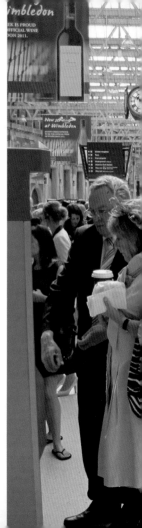

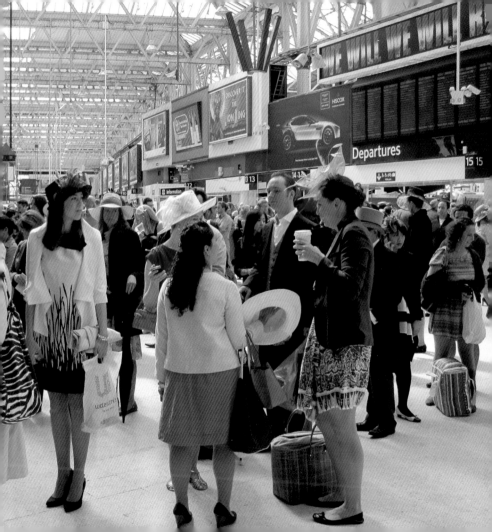

Station Scene, Norwich

The privatisation process instigated in 1993 plunged the railways into chaos, most of which was both predictable and unnecessary. Twenty years on, things were getting better. There were new trains, and considerable investment has improved both stations and infrastructure. Today, passenger train figures can match the great days of the 1950s, even though the modern network is much smaller. Even freight traffic is improving. However, the cost to the taxpayer in subsidies to the operating companies is higher than in the days of nationalised British Rail.

This photograph, taken in the summer of 2011, shows some aspects of Britain's railway services in the post-privatisation era. Trains, usually modern, comfortable, safe, fast and well-maintained, carry the varied, and often changing, liveries of the operating companies, adding colour and interest to the railway scene. Meanwhile, stations are being restored and improved, without destroying their history. Typical is Norwich, where the 1886 French-style building has been carefully restored, with many original details retained, such as the decorative ironwork supporting the glazed ridge-and-furrow platform awnings.

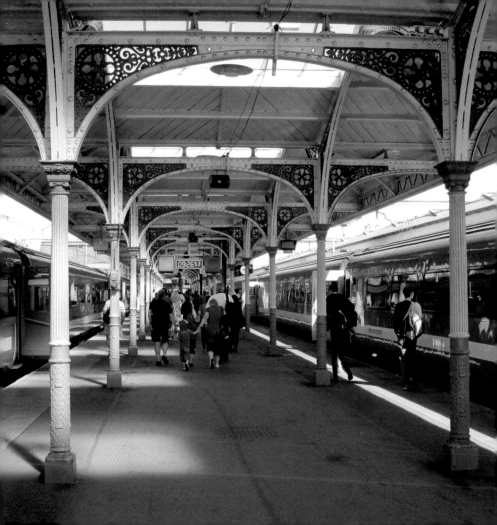

Eurostars at London St Pancras

The opening of the Channel Tunnel in 1994 finally connected Britain to the European high-speed rail network, though for some years the Eurostars were forced to operate in Britain at slow speeds along ordinary track. Finally, in 2007, the high-speed route from London to the tunnel was opened, along with the new London terminus at St Pancras.

In the early 1960s, St Pancras, in many ways London's most magnificent station, was scheduled for demolition. Luckily, the outrage that followed the destruction of Euston compelled British Railways to think again and by the 1980s station redevelopment was always balanced by careful conservation of their Victorian heritage. Today, Eurostars arrive and depart beneath the sky-blue cast iron of W. H. Barlow's great train shed of 1868, while at the street frontage of the Grand Midland Hotel, Sir G. Gilbert Scott's Gothic masterpiece and one of the finest Victorian buildings in Britain, is now once again a hotel, after decades of disuse. The station's subterranean goods yard is now full of shops and cafes, and an exciting new station at the far end looks after domestic traffic. The photograph shows this blend of old and new, which has made a tired old Victorian structure into one of the world's greatest railway stations.

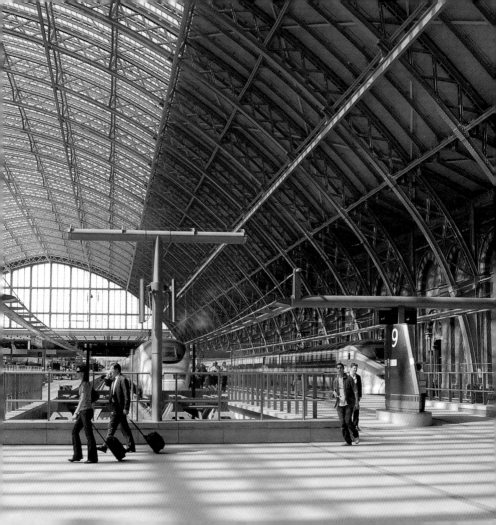

Acknowledgements

The author and publisher would like to thank the people who have facilitated the use of illustrations, credited below. Every attempt has been made by the publishers to secure the appropriate permissions for materials reproduced in this book. If there has been any oversight we will be happy to rectify the situation and a written submission should be made to the publishers.

Image credits are as follows: p.47 H. C. Casserley (Atterbury Collection); p.51 © Daily Herald Archive/National Media Museum / Science & Society Picture Library; p.53 © National Railway Museum / Science & Society Picture Library; p.60 Colour-Rail (Atterbury Collection); p.67 R. C. Riley (Atterbury Collection); p.71 C. Gammell (Atterbury Collection); p.75 Michael Mensing; p.77 Brian Webb (Atterbury Collection); p.91 G. F. Heiron (Atterbury Collection); p.93 E. Wilmshurst (Atterbury Collection); p.95 B. Watkins (Atterbury Collection); p.101 Gavin Morrison; p.103 Colour-Rail; p.105, p.107, p.109, Paul Atterbury

Images on p.15, p.39 and p.89 are taken from the *Poster to Poster* series of licensed books published by JDF and Associates Ltd, Gloucester and used with their permission.

All other photographs are from the author Paul Atterbury's Collection.